Table of Contents

A Look At The History Of Airbrush Art2

Why Airbrush Art Fits For Everyone5

Airbrush Art Supplies ..7

Types of Airbrushes Available ..7

Airbrush Art-Your Airbrush Parts9

Airbrush Art-Taking Care of Your Airbrush11

Airbrush Art Paints ..13

How To Create Your Own Stencils15

How To Prepare Various Surfaces17

Your Airbrush Art ...19

Airbrush Art Tips For Beginners ..19

How To Get Inspiration ..21

Ways To Gain Exposure ...23

Airbrush Art Mediums ..25

Airbrush Art On T-Shirts ...25

Airbrush Art On Nails ...27

Airbrush Art On Automobiles ..29

Airbrush Makeup ...31

Airbrush Art Tattoos ..33

Airbrush Art Tattoo Kits ...35

Care Instructions For Airbrush Art Tattoos38

Learning More About Airbrush Art ..40

Airbrush Art Expert-Pamela Shanteau40

Books for Beginners to Advanced..................................43

DVDS For Beginners..45

Advanced DVDs..47

Airbrush Art Magazines ..49

A Look At Workshops..51

Why You Should Learn Micro Airbrush Art53

A Look At The History Of Airbrush Art

Airbrush art is a popular form of painting various designs on various types of surfaces. Everything from skin, clothing, canvas and automobiles are being used to show fantastic works of art using airbrushing. Motorcycles and building murals are also a target for an artist to show off their creativity with airbrush art.

The history of airbrush art is just as fascinating as the creative designs that artists are using airbrushing for. Experts believe that a primitive form of airbrush art was used by ancient civilizations. The method believed to be used in this primitive form of airbrush art was the use of a hollow bone in which to spray the paint out of by blowing through it. While this is a very primitive method compared to modern day forms of airbrushing, it does still work. Take a look at children's airbrush art kits that require the child to blow through one end of tube to create the airbrushed art. Now ancient forms of airbrush art have bled over to modern day children's crafts.

In 1893 the world seen a more modernized version of airbrushing when Charles Burdick patent the first airbrush device. This device would be used for retouching photographs until around the 1920.

During the 1930s airbrush increased when advertisement agencies jumped on the bandwagon to create advertisement of new products. Soon airbrushing would be used to paint Pin-Up girls on to the American planes during WWII. This is where airbrushing started showing up in the more modern world in the form of art.

In the 1940 Walt Disney would show the world a new use for airbrush art. Walt Disney would take airbrush art to the animated screen. The backgrounds for Walt Disney's animated movies were created using airbrushing. Airbrushing allowed them to create shadows and lighting tricks to achieve a more realistic looking background. While even this seems primitive compared to what we can do with animated movies as well as for airbrush art, this method did pave the way for both the improvement on animation and airbrush art.

The 1960s brought us even closer to what we now know we can do with airbrushing. Airbrush art in the 1960s made its way into the music world. Album covers were done using airbrush art to create the whole hippy style images. The wild psychedelic artwork that was popular with that era were done thanks to the use of airbrushing. Tie dyed looks and large hippy flowers and even the peace signs were making their way onto vehicles during this era. Airbrushing the artwork on took a lot of time out of painting the vehicles over doing the designs by hand. Thus airbrush art was being experimented with on vehicles at this point.

The way we use airbrushing now to create art surly has come a long way from the primitive methods used by our ancestors and even our parents. Now a days we can see airbrush art almost everywhere on almost every type of surface. The only limits now with airbrush art rests in the limits of the individual artist.

Why Airbrush Art Fits For Everyone

The thing with airbrush art is that it can be done for just about anything imaginable. Artists have been airbrushing a variety of surfaces for years now. The images they create are just a vast as the surfaces that they are airbrushing them on. This is why airbrush art fits for just about everyone around.

Classic paintings can be airbrushed onto canvas to give for great wall art. With airbrushing the paint goes on to the canvas more evenly than if it had been hand painted. Also the time frames are shortened when the paintings are airbrushed versus hand painted. Family portraits can be airbrushed over hand painted as well to give for a more realistic painting.

The interior of your home is also a place for airbrush art. You can go with a nice mural on your wall to give a room in your home an artsy feeling. Or you can scale it down and just airbrush a border at the tops of the walls. Airbrushed borders look more decorative than glued on paper borders on your walls. Thus the interior of your home can be your canvas for your airbrush art. Whether you want bold or subtle the choice is yours when you airbrush. You do not have to be limited with just your walls inside your home. Everything in your home can prove to be an area to show off your creative side. Airbrush art can go on your cabinets, doors, toilet seats and so much more. Remember though that this does not have to be anything bold.

It can just be some simple flowers or ivy trim but the choice is yours. Clothing is open to airbrush art as a way to create unique one of a kind clothing and accessories. Airbrush art can just be wording that you have added to your shirts or other clothing or it can be creative pictures of things that interest you. Either way you are guaranteed to have clothing no one else does if you add your own airbrush art to them.

Automobiles and motorcycles are other areas where airbrush artists can get creative and create masterpieces. Many artists are making a name for themselves with custom airbrushing art onto automobiles and motorcycles. The cost for this art is expensive and you can cut your costs down by learning how to do it yourself. Also by doing it yourself you have more of a say in how it will turn out.

As you can see airbrush art can fit for anyone's tastes and needs. With airbrush art you can go extreme with fantasy art or murals of realistic scenery. You can go with bold colors schemes or subtle colors. The possibilities with airbrush art are unlimited and only limited to the artist imagination. Any scene, any surface and everything in between can be airbrushed. Airbrushing looks realistic and saves time over hand painting. If you want airbrush done on any surface or for any reason and do not want to learn then there are many airbrush artists out there that you can hire for any of your airbrush art needs.

Airbrush Art Supplies

Types of Airbrushes Available

When doing airbrush art there are different types of airbrushes that you can choose from. Depending on what you are actually creating will also determine what airbrush you need. Once you understand the different options that are available and the benefits of each option you will be better able to determine which airbrush you need for which projects. For the paint you have an internal mix or an external mix.

The internal mix is when the air and the paint both mix inside of the airbrush. This will create a atomized fine dot spray pattern. This makes the internal mix a good choice for fine detailed work in your airbrush art. The point at which they come together is in the head assembly. The external mix is where the air and paint come together outside of the head assembly or the fluid assembly. These airbrushes create a large dot pattern. Larger airbrushed areas are better done with the external mix. With the larger dot pattern you are able to spray more areas in less time.

Airbrushes also come in single and dual action. This refers to how the airbrush functions. With single action only the air is controlled with the trigger. The trigger will control the air and the amount of paint that comes out is determined by the needle adjustment on the back of the airbrush handle. Dual action is when the trigger on the airbrush controls both the air and paint. The trigger is pressed down for the air and back for the paint.

Now when it comes to the feed on the airbrush there are three types of feeds that you can choose from. The type of feed you choose will also depend on what you are doing as well as what you are comfortable working with. The gravity feed is a top mount cup that uses gravity to pull the paint down into the airbrush. This feed is great for airbrush art designs that call for fine detail as the gravity feed uses less air pressure. The less air pressure means that you can use slower movements when airbrushing. The bottom feed is where the cup is mounted to the bottom of the airbrush and the paint is brought up via a siphon tube. It is for this reason that the bottom feed is also referred to as a siphon feed. Since the artist can attach the cup to the bottom of the airbrush the colors can be changed quickly by using different cups prefilled with the colors needed.

Airbrush art also uses airbrushes with a side feed. The side feed has a cup that mounts on the side. Since the side feed can be rotated the artist can airbrush either horizontal or vertical. Fine detail can be obtained with the side feed the same as the gravity feed. The advantage of the side feed is that unlike the gravity feed you do not have a cup mounted to where your vision is being obscured while you are creating airbrush art.

Airbrush Art-Your Airbrush Parts

All beginner airbrush artists should understand the parts of their airbrushes and what these parts do. After all how can you create great airbrush art if you do not truly understand your airbrush equipment? Take the time to gain knowledge of all the parts of your airbrush will help you to learn how to properly work your airbrush and also how to take care of it.

If your airbrush is internal mix then it will have a needle. The purpose of the needle is to control the paint flow. Any damage to your needle can cause very bad paint spray patterns. It is important to keep your needle from getting bend and either straightening the needle or replacing the needle.

The air cap and head assembly are on the front of your airbrush and they cover the tip of the needle. The purpose of these parts is to control atomization of the paint spray. Should these parts become dented or damaged in any way you should replace them immediately. Damage to the air cap and head assembly will affect the performance of your airbrush. Thus like the needle you will be unable to create desirable airbrush art. Both the needle, air cap and head assembly can be purchased at almost any craft or hobby shop that sells airbrushes and airbrush parts.

The airbrush trigger is what allows you to actually operate the airbrush. In a single action airbrush the trigger controls the air flow. In a dual action airbrush the trigger controls both the air flow and the paint flow. Beginners should really take the time to practice on how the trigger works so that they can perfect their ability to airbrush. Your airbrush will have a back lever as well that acts to shut off the air

flow and paint flow when the trigger is released. If this should be come damaged then you could have serious problems with your airbrush. Don't worry though it is not hard to replace these parts should there be any damage.

Your airbrush will have a handle on which you can hold onto the airbrush with. Airbrush models come with either a solid handle or a handle with an opening. The purpose of this opening is so that you can adjust the needle without removing the handle in a single action airbrush. Most experienced airbrush artists will actually take their handle off so that they can deal with clogging issues without delay. So the choice is yours as to whether or not you want the handle on or off of your airbrush while you are creating airbrush art.

Pay special attention to the threads on your airbrush. The threads are located on the head assembly and where the air hose connects to your airbrush. If these threads should ever become cross-threaded then you could end up with an air leak. An air leak will affect the function of your airbrush so make sure to take care not to cause any cross-threading in these areas.

Airbrush Art-Taking Care of Your Airbrush

One of the main things that you need to know how to do with airbrush art is how to take care of your equipment. Keeping your equipment in proper working order and clean will save you a lot of money and hassles. Equipment that is not kept clean and properly cared for will break down more often. Also equipment in is not taken care of and cleaned will not produce quality airbrush art.

First let's look at how to clean your airbrush. One rule of thumb to remember is the type of cleaner you use will depend on the type of paint you use. Solvent based paints should be cleaned with a solvent based cleaner. All water based paints can be cleaned with water or a commercial cleaner designed for airbrushes. Windex is useful when cleaning your airbrush between color changes while using your airbrush. Never soak or leave your airbrush exposed to Windex for any real length of time. You should not have to take your airbrush apart every night to clean it, it is alright to only do a complete break down and cleaning once a month. Just make sure you do not go any longer than that. When you take it apart to clean, soak it in a commercial grade cleaner overnight. The next morning take an airbrush cleaning brush to it. Make sure to oil your airbrush up before putting it back together.

Most artists find the using their airbrush without the needle cap gives them more control. Removing the needle cap is fine but should you hit your airbrush against something or drop it you could end up damaging the needle itself. So to take care of your airbrush make sure that when you are not using your airbrush that you replace the needle cap back onto it. This will give a little protection to the needle

itself should the airbrush happen to fall. A damages needle can be disastrous to your ability to create high quality art, because if you are unable to straighten a bent needle back out or the needle should break completely you will not be able to finish your airbrush art until you can get a replacement.

If you do end up bending your needle you can try and straighten it with pliers. Place the tip within the pliers and gently try and straighten it back out. Remember to do this gently so that you do not break your needle.

The better care that you take of your airbrush the longer it will last. So keep your airbrush clean with the right cleaners and once a month do a full break down and cleaning. With needles most artist find that the airbrushes coming out of China bend easier than any of the other airbrushes. So look for one that is made elsewhere so that you do not have to keep trying to straighten a bent airbrush. The best airbrushes to use that are the easiest to take care of, are name brand airbrushes. The knockoffs are harder to take care of because are made from cheaper parts that break easier than the name brands.

Airbrush Art Paints

When doing airbrush art there are many types of paints that you can use. The type of paint that you use will depend on what you are airbrushing. Some paints can only be used on certain surfaces and are not safe to use on other surfaces. So make sure the paint you are using is safe for the surface you will be putting your airbrush art onto.

Water soluble acrylic paints are used for airbrushing art onto plastic, metal, vinyl, wood, ceramics and cloth. This makes this type of paint the choice for airbrushing art onto your model cars or airplanes. This is also the choice for airbrushing t-shirts as well. But as long as your project is made from the above material you can use water soluble acrylics for your airbrush art designs.

Depending on which brand of acrylic paint that you go with, you may need to thin it down so that it flows freely through the airbrush. Also some acrylic paints require that they be heat set if used on clothing. You can heat set by placing a protect cloth between the design and the iron and ironing the design or you can turn the material inside out and place in the dryer on high heat. If the acrylic does not require heat setting on fabrics then you should still protect the design from fading when washed. To do this place the clothing into a sink of cold water and salt and allow to soak. Then the clothing can be laundered without risk of damaging the airbrush art design.

When doing airbrush art in the form of body art or tattoos you can use paint that is usually termed in two ways. Usually this paint is referred to as body art paint or

airbrush tattoo ink. Both forms are basically the same and maintain a realistic tattoo look. This paint will last and is waterproof. To remove you will either just let time take its course and the tattoo will fade or rub with baby oil to remove. To help you tattoo last longer apply talc powder daily. This will help the paint to stay on the skin better.

Acrylic nail art paint is needed when doing airbrushing art on nails. These paints clean up with water while they are still wet. So if you do get any on the skin or another surface where not needed then clean up immediately while it is still wet. The paint will become permanent when it dries. There are a lot of possibilities with acrylic nail art paint that you can do when creating your airbrush art. Colors can be mixed to create your own unique color for your artwork.

When putting airbrush art onto an automotive use acrylic enamels. These are not only cheap but they will not clog up your airbrush like lacquers. Also make sure that you buy mixed colors and avoid any tinting colors, since they do not contain any driers in them.

When creating airbrush art remember to use the right paint for the project. Beyond that, when it comes to paints and airbrush art the possibilities are endless.

How To Create Your Own Stencils

There are two forms of doing airbrush art. One way is that you can use stencils or masks to airbrush your artwork on to your project. The other way is that you can freehand the design onto your project without the use of stencils or masks. Most stencils and masks that you purchase are reusable. The stencils are made from different material depending on what the stencil will be used for. But no matter what material your stencils are made from they all have to things in common. One the stencils can start to get expensive purchasing. Secondly you are limited to only creating designs based on the stencils that you can get your hands on. While these stencils can greatly aid you in your airbrush art, they also can hinder your creativity. So the best way to deal with having you use stencils and reduce costs as well as leaving your creativity open is to create your own stencils.

If you can trace, you can create your own stencils cheaply. All you need to do is find a design that you like and then trace it out onto paper. Make several copies of the design since you will be cutting on them. Also the airbrush paint will get them wet and they can start to tear. You will need to keep the original design so that you can refer back to it. After you have made copies of your traced design start, cutting out the areas that you need to cut out. Then place the home made stencil onto your project and begin to airbrush your project.

If you want to use a more durable material to create your stencils you can use the plastic pocket folders. These can be picked up rather cheaply from the store in the office supply section or hit the back to school supplies. You will

need an exacto knife to cut your design out. Depending on the size of your stencil you can probably create more than one stencil from this plastic folder. If you purchase the see through folders then you can use these for stencils even if you are limited to tracing your design onto the plastic folder prior to cutting it into a stencil for your airbrush art.

No matter what material you go with make sure that you remember to cut out your areas slowly. By taking your time you can make sure that everything matches up the way it should. If you are doing a stencil for say a dog then you would want to take your time and make sure that the eyes were the same size, the nostrils were cut out shaped the way they should be and so on. If you rush you could end up messing your stencil all up. The stencil is to aid you in creating your airbrush art and is a big part of the art process. If you have to then practice on a scrap piece of material till you get use to how the knife works and how to properly cut out the areas. This will help to ensure that you create a working stencil for your airbrush art.

How To Prepare Various Surfaces

When you begin an airbrush art project, you will first need to prep the surface. The prep work that you do will be determined by what type of surface you will be airbrushing. The prep work to the surface will ensure that the paint sticks to the surface and that nothing is interfering with the airbrushed design.

For airbrushing t-shirts, sweatshirts, denim and other natural fibers you first need to wash the material. By washing the material you will remove any loose fibers. Also washing the material will take care of any shrinking prior to placing your airbrush art design on to the material. So make sure that you have washed and fully dried your material before you begin.

Leather needs to be wiped down with rubbing alcohol prior to doing any airbrushing. This will remove the oil that is on the leather. The oil will prevent the paint from sticking to the surface. Make sure that all the leather has been wiped down and that the alcohol has dried before beginning. When you begin you need to place a base coat of Opaque White first before you begin your actual airbrush design.

Wood surfaces should be sanded prior to doing any airbrush art. Take the time to use sand paper and lightly sand the wood down by hand. If you are doing a mural on a wood floor then use a hand floor sander. You don't want to mar the wood only remove any rough areas. If the wood has been waxed or has a gloss coat then sanding this will remove this and allow for the paint to stick to the surface.

Skin should be cleaned with rubbing alcohol to remove any oils from the skin. The skin's own natural oils will prevent

the airbrush paint from successfully sticking to the skin. This will cause the airbrush art tattoo to come off to soon. The use of talc powder after the design has dried will help to keep oil from building back up and thus still ruining the airbrushed tattoo.

Nails should be clean and buffed prior to beginning. Buffing the nails will give for a rougher surface for the paint to cling onto. Prior to actually airbrushing the nails, a base coat should be applied. There are actually two reasons for the base coat. This base coat will help protect the nail from the paint and help the paint to adhere to the nail better.

Metal should be wet sanded to give a rough grainy effect. This rough grainy effect will help the paint to adhere to the metal. With metal actually being smooth the paint will have a hard time sticking to the smooth surface. This is why it is important to wet sand the metal first. A base coat should be applied to the metal before any airbrush art design is started.

Take your time and make sure that the surface you are working on is prepared thoroughly so that the paint will stick. You don't want to get to work on a great airbrush design only to realize that the paint is either not sticking or looks messed up.

Your Airbrush Art

Airbrush Art Tips For Beginners

When you are first learning something new, things can sometimes get a little tricky. You are trying to create a new form of art and are finding that some things may be a little difficult to get to happen. The experts showing you how to do something on a video make it look so easy. You will believe it is easy until you get out there and try to do it yourself. It is at this moment that you realize that you are not able to do what they did. To start with you need to practice with simple techniques until you get the hang of how to do them. Simple techniques will give you a better understanding of the process and allow for you to have a foundation in which to build on.

When you first try using an airbrush you need to use a cheap surface that you can just practice with. A simple black paint will work for this, no need to buy additional colors. The only thing you need to be doing is experimenting with the airbrush. Get used to how it works and feels in your hand. Practice spraying the airbrush at your cheap surface while you learn just what pressure is needed where. If you are using a double action airbrush you should be experimenting to see how far back gives you how much paint spray.

Once you are comfortable using the airbrush then you should work on creating shapes with your airbrush. Using a cheap surfaces airbrush circles, triangles, squares and rectangles. While this may seem stupid it will help you to learn how to create designs using your airbrush. Continue

to practice with shapes until you are able to perfectly render airbrushed shapes. Once you have the ability to render the shapes, you can move on to rendering shapes in different textures. This means that you should work on creating shapes with thin lines and shapes with thick lines. This will help you to learn more how to use the airbrush to render broad designs as well as fine detail.

Now that you can render the shapes you should move on to using stencils. This will give you a feel for stencils as most beginning airbrush artists will use stencils to create their airbrush art. Practice using stencils on a cheap surface using your black paint. You will also gain knowledge from trial and error on how to remove stencils without disturbing the paint.

The type of paint that is best for a beginner just learning is Golden Airbrush Colors. These paints are ready to use and will save you from having to deal with thinners and such. Save those types of paints for when you have gained yourself some experience with airbrush art. Stick to ready to use black paint from Golden Airbrush Colors because it really does not matter how the paint looks at this point. The only thing that matters is that you learn the basic techniques so that you have a good solid foundation of skills in which to advance you forward with.

How To Get Inspiration

Sometimes when trying to come up with designs your mind can go blank. You find yourself unable to come up with a design for a certain project. While airbrush art can give you endless possibilities it can also leave you stumped on a design project. Finding inspiration though for your airbrush art can come from many forms. The different places that you can look for inspiration can help you when you are stumped on what to do with a project.

When you are feeling the creative block coming on then start looking around you. Anything can be a basis for inspiration, especially if you change your scenery and look around your new surroundings with open eyes. Cooped up in a studio too long, then go out to the park and open your eyes to everything that you see. Derive inspiration from various sites around you and incorporate them into one great piece of art. See two kids on a seesaw at the park? Turn those two kids into angels on a seesaw cloud in the sky. See a couple of kids playing ball? Then turn them into angels and the ball into a cloud. Now put all of this into one art design. See where I am going with this? You just took two things you seen incorporated them both together turned them into something else and now you have a unique floating cloud playground.

Inspiration can also come from books as well. Go to the library and check out some art books to help you get some inspiration to get you going again with your creative design. Sometimes by looking at other people's works you can get past your creative block and start creating your own airbrush art again. Any form of art will work to give you inspiration since after all you can airbrush any design

you see. Take the time to look at the art in the books and see them as your own. Think of how you would have created that picture had it been yours. Then go from there and start drawing out how you would have made it look. Once you are happy with it then airbrush it on to your project to create your own unique airbrush art design.

If you don't want to get outdoors to look at new scenery and you don't want to go to the library then you can just surf the web. The internet if full of inspiration for your airbrush art. Start looking at various images and keep surfing until you find the one that gets your creative juices flowing again. Print the picture that helps you so that you can keep it around as your muse for as long as you need it. It may take a while but with the limitless supply of images and artwork on the internet it is sure to keep you supplied with some inspiration.

Sometimes you just need to step back and take a breather to get your inspiration back. If you find that you are not getting inspiration no matter where you are looking then it is definitely time you stepped away from the airbrush art for a while. Take a few hours to do something other than airbrushing and let your mind go for a while. You will be surprised how quickly your inspiration comes back and creative juices start flowing when you just take a breather.

Ways To Gain Exposure

Getting known in any industry will take time but you have to get your work out there in front of people. It is only after you have people looking and admiring your work will you finally start to become known. There are several ways that you can get your airbrush art seen. Most of these ways will actually cost you nothing. The use of the internet has made it where you can show your work to the world for free.

Almost everyone on the internet has started using a blog. Well you should be no different. Get yourself a free blog and start showcasing what you can do. Don't just put up pictures of your work though. Make sure to actually talk to your audience. Tell them about yourself and your passion for airbrush art. Show some pictures of your work and tell your audience how you created that design. Talk about the paints that you use, the types of airbrushes and so on and so forth. By discussing your techniques and sharing your insight you will show your audience that you are an artist that knows what they are doing.

Once you have a couple of posts up telling about yourself and showing off some of your work then you are ready to get your blog seen by the world. Some blog sites such as Shout Post and Tblog actually show your blog posts off for you to other bloggers. This helps to get your blog some traffic. If you choose a blog host that does not do that then you should look into some blog traffic exchanges. After all what good is the blog if no one is seeing it? So find a couple of blog traffic exchanges and register your blog. A good traffic exchange if Blog Explosion. This exchange allows you to not only surf other blogs for traffic but lets

you put your blog in the Battle of the Blogs for a chance to win traffic as well as ranking. Either way you are getting your blog seen and this means your airbrush art is getting seen.

Another ways to get your airbrush art seen is to take a look at some airbrush art websites. A lot of these websites offer a gallery that artist can upload images of their work onto for free. This gets you seen by the webmaster of the site as well as other artists. Your work will be put up there for the sites traffic to see and thus getting you known in the industry. Take the time to submit several pictures of your work to several website airbrush art galleries. Don't depend on just a couple of pictures on one or two sites to get you known.

Myspace is also a great way to get seen and gain some exposure. With myspace you can create a profile that is dedicated to you as an artist. Upload pictures of your work and take the time to create a couple of videos as well. Create the videos so that they show you in the act of working on your airbrush art. Make sure to use good lighting so that your videos truly capture the art of what you are airbrushing. With millions of users on myspace you are sure to get yourself seen by people who are interested in your work.

Airbrush Art Mediums

Airbrush Art On T-Shirts

Putting airbrush art on T-shirts can be a fun and creative hobby. For those that want to take it a step further it can also be fun and exciting business. T-shirts containing airbrush art are popular and unique to wear. What makes airbrushed t-shirts so unique is that one of a kind images can be created giving the wearer a shirt that no one else has. Thus making for a pretty fun hobby or profitable business.

The great thing with airbrush art is that you really do not have to know how to draw. All you need to know how to do is successfully use the stencil that you wish to use for your design. The main key is learning how to control the airbrush gun so that you can get the paint only where you want it and not overcast the paint where you do not want it. Once you master that then your options are endless with the vast array of stencils out there.

A bottom feed or siphon feed airbrush works best when putting airbrush art onto a t-shirt. You should always stick with a name brand airbrush when airbrushing. The best name brands to go with are the Iwata or Badger. The Paasche is also a good quality airbrush to go with. You will save yourself money in the long run when using a name brand versus a generic airbrush.

When choosing an airbrush compressor keep in mind that put airbrush art onto t-shirts does require a high psi. The psi setting should be between 40 and 60. Make sure that

your compressor is rated for the type of work you are going to be doing. In this case it will be airbrushing t-shirts. When doing airbrush art onto t-shirts as a business then invest in a commercial air compressor. It will be worth it in the long run.

Most of the times you will need to heat set your paints so that they can be washed without fading or bleeding. There are a few ways that you can heat set your airbrush art onto the t-shirts so that it lasts. One way is all the design to fully dry then place a cloth over it and iron the shirt with the cloth between the t-shirt and the iron. Always keep the iron moving though so that you do not burn the material. Another great way if you are doing this at home is to allow the design to dry then turn the shirt inside out and throw it into the dryer for about 40 to 45 minutes on the highest heat setting. After this your design will hold up to laundering.

If you use a paint that does not require heat setting then you should still set the design. A great way to do this with paints that do not require heat setting is to place the t-shirt by itself into a sink full of cold water that has salt mixed into it. The cold water and salt will help to keep the shirt when it is laundered from fading or bleeding.

Placing airbrush art onto t-shirts can be fun and exciting. But you are not limited to t-shirts. Get creative and airbrush designs onto cotton underwear for your significant other. Airbrush socks for your family. The possibilities with clothing and airbrush art are limitless.

Airbrush Art On Nails

Almost everyone loves some form of art or another. A lot of women love to get their nails manicured. So why not combine the two together? Well that is exactly what has happened. Airbrush art has combined with the manicure to give women great opportunities to use their nails to show off great artwork. Airbrush art applied to the fingernails gives a great flare to a manicure. The designs are only limited to the stencils in which the artist can get their hands on and the artists' imagination.

This form of airbrush art has become very popular and a lot of salons around the world are offering this to their clients. Airbrush art is also available on fake nails and are sold at almost every store that carries fake nails. You two can get in on this craze and start you own fun and exciting business offering airbrush art on nails.

Airbrush art on the nails is not for the beginner just getting started in airbrushing. The work area is very small and the artist has to have mastered the techniques involved with airbrushing. One main problem that beginners face is over spraying. Over spraying is when the artist sprays outside of the area in which they are trying to spray. When working with nails you do not want to end up airbrushing the person's fingers. So before attempting to do airbrush art on nails gain some experience with airbrushing on larger surfaces.

Depending on the type of airbrush art you are doing will determine the type of airbrush that you need. When doing airbrush art on nails go with either the Iwata HP-A or the Iwata HP-B. These are great for airbrushing nails. Even if

you do not go with the Iwata though remember to always go with named brand and never use any knockoff airbrushes.

You will need an air compressor that is designed for airbrushing on nails. The best air compressor to use is the Iwata Studios Series Silver Jet Air Compressor. While this one is the best one you can go with any small compressor that has an 18 psi. Preferably get an air compressor that will adjust between 10-18 psi if you do not go with the Iwata Silver Jet.

To do airbrush art on nails you will need nail art stencils or nail art masks. The nail art masks are reusable masks that have an adhesive that does not leave any residue on the nails. Of course if you are really creative and very good you can freehand the airbrush art right onto the nails.

If not then take the time and invest in nail art stencils and masks. The paint that you will use when doing airbrush art on nails is water based. A bottom coat and a top coat are what protect the water based paint from being damaged. You will also need to spray a light coat of what is called varnish between the artwork and the top coat. Varnish is just a water based clear coat that will protect the paint from getting brush strokes when you apply the top coat.

Airbrush Art On Automobiles

By airbrushing art onto your automobile you can create a unique paint job that really shows off your style. Once you have the basics down on how to work the airbrush then you can pretty much create some great airbrush art on your automobile. It does not matter if you can draw or not. There is no need to be able to free hand you art work either. Stencils can be used to airbrush art on to your automobile just the same as any other surface or project. The art that you create with airbrushing is only limited to your own imagination. There are plenty of places to acquire stencils or get design ideas so that you can create your own stencils.

If you do create your own stencils for airbrushing your automobile do not use paper to create your stencils. Automobiles need lots of paint and this will damage paper stencils rather quickly. So stick with plastic or vinyl material for your stencils. A great cheap plastic to use for stencils is thin plastic folders. These can be picked up cheaply in office supply areas of most stores.

When doing airbrush art there are different types of airbrushes that are available. The best airbrush to use for putting airbrush art onto an automobile is a gravity fed airbrush. This is the one that professionals use and will give your artwork a high quality look. The paint can be automotive paint but make sure that you use a well-ventilated area as the fumes can pose a health hazard. It is best when using automotive paint to wear a respirator at all times. When using automotive paint make sure that it is thin enough to flow through the airbrush. If the automotive paint that you have chosen does not flow then thin it down

so that it flows. The paint should be thinned to about a milk thickness. A good automotive lacquer will work fine to thin down your automotive paint.

Different airbrush art calls for different psi on your compressor. PSI stands for pounds per square inch and for automotive airbrush art you need a compressor that has a psi of 55-65. Iwata is a great name brand to go with and they offer four compressors that will work for airbrushing automobiles. Badger is another good name brand that you can go with. They offer several air compressors that will work when doing airbrush art on automobiles.

When it comes to any part of your actual airbrush equipment such as the airbrush and its parts as well as the compressor make sure to go with name brand. Do not use any knock offs. These will cost you more money and lots of headaches in the long run. You get what you pay for and when it comes to airbrush art you need to go with names that you can trust. A lot of knock offs also will give for a harder time finding replacement parts when they tear up. Knock offs will tear up quicker than the name brands. So save yourself the hassle of being in the middle of your airbrush art project on your automobile and find yourself unable to get replacement parts for your airbrush equipment.

Airbrush Makeup

Airbrushing can be done on almost anything that you can imagine. Airbrush art is one way to take something and turn it into a master piece. Over hand painted art, airbrush art can be done in less time but with the same great effects if not better. There is more that you can do with airbrushing that you cannot do with hand painting. You can take airbrushing and create a beautiful mural on a concrete wall to turn that once bland wall into a work of art worthy of some attention. While you can do this by hand the time factor makes airbrushing a better choice.

Airbrush art can also be applied to the body to create temporary tattoos and thus uses the human body as a canvas for an artist's imagination. Cigarette lighters are also being used as a way for artist to show off their airbrush art. The once simple looking lighter is now a display item with awesome art on it.

So with everything being available for artist to use as a canvas for their airbrush art and with art being the taking of something and then turning it into a masterpiece, there is now a question posed. Is airbrush makeup just another form of airbrush art? Can the application of makeup with the use of an airbrush be art? Or is it still just the application of makeup that just happens to use an airbrush?

When looking at what airbrushing does when used to apply makeup, a lot of people do believe that this is a form of airbrush art. When make-up is airbrushed on the effects of what it does to the subject can be really drastic. Take a woman who has flawed skin and airbrush a light

foundation onto her face and you now have a woman with perfect skin. The great thing is that the foundation is light weight and barely noticeable. Airbrush makeup has been able to take a woman that is plain and turn her into an exotic beauty with the right application of certain makeup. The effects of airbrushed makeup are more natural but at the same time more dramatic than the use of regular make up.

The application of makeup takes time and a lot of practice to be able to do perfectly. The human face is one canvas where an artist does not want to mess up. One must be sure of their abilities with not only the application of the right makeup but also with use of an airbrush to apply those makeups.

Those that apply make-up are considered artists and airbrushing on makeup is just another great way that they have found to show off their artistic median. The make-up goes on water and has to dry. As it dries those watching can see the transformation of the subject from what she was to what she is now becoming. This is why a lot of people do believe that airbrush makeup is another form of airbrush art.

Airbrush Art Tattoos

A fascinating form of airbrush art is the airbrush tattoos. These tattoos can be applied to any part of the body and last longer than most temporary tattoos. An airbrushed tattoo will last for 7 days unlike other temporary tattoo that start to come off when you are bathing. It takes time or baby oil to remove an airbrushed tattoo. Tattoos that are done with airbrush art look realistic compared to other temporary tattoos.

Henna as temporary body art does last for a while requiring time and lots of exposure to water to fade and disappear. Henna though takes a long time to hand paint onto the body. The bigger the artwork the longer it will take the artist to pain the henna design on. Airbrush art goes on quickly thus saving lots of time compared to henna as well as airbrush art is waterproof. Unlike henna lots of exposure to water still will not fade your tattoo. Where it would take an artist 6 hours to pain on a large henna design the same artist could airbrush the design on in around 30 minutes. This is a major amount of time saved for the artist as well as the recipient that must stay still during this process.

Another great thing with using airbrush art to create tattoos over real tattoos, is that there is no risk of infection due to piercing of the skin with a needle. There is no healing time needed with airbrushed tattoos. The great part is there is no pain involved. A real tattoo come with pain and is one of the reasons that some people do not get them. So using airbrush art to create a tattoo gives people the chance to have realistic tattoos without the pain.

Real tattoos are permanent and you are stuck with whatever you get. The only way to remove a tattoo that you do not like is to either do a cover up tattoo or go and have laser surgery to remove the tattoo. With airbrushed tattoos you can get rid of it with baby oil or just wait about 7 days and then it is gone. No need to go and get an even bigger tattoo to cover up the offending one or go through the hassle of laser surgery.

To do airbrush art in the form of tattoos you will need certain products. First off you will need an airbrush gun, 10' Hoses braded hose, stencils, glass airbrush bottles and an air manifold. Then off course you will need airbrush paints that are designed for the human skin. This is usually referred to as airbrush tattoo ink. To finish up the process you will need talc powder and 70 percent alcohol.

The stencils are available in a wide variety of designs thus giving you almost limitless creativity when using airbrush art to create tattoos. The talc powder is to be applied to the tattoo after it has dried. The powder helps to keep the tattoo from fading. The 70 percent alcohol is to clean the airbrush gun and glass bottles with after you are done.

Airbrushed art used to create tattoos will last for 7 days on the norm. Now if you have extremely oily skin it could start to fade in a couple of days. If you have dry skin it could last past the 7 days. To help keep your airbrushed art tattoo for as long as possible keep applying talc powder to it every so often. If you are ready to get rid of it then just rub it down with baby oil and it will come off.

Airbrush Art Tattoo Kits

Airbrush art in the form of temporary tattoos are a fun and exciting way to create temporary tattoos. These tattoos last longer than other temporary tattoos and give a more realistic look to them. Unlike henna that must be hand painted airbrush art tattoos can be completed in a fraction of the time.

Airbrush art kits give you the necessary tools to get you started creating your own airbrush art tattoos. These kits come in a variety of sizes and price ranges depending on the dealer you are purchasing them from. Some dealers also will offer low grade products for a low price making you think you are getting a deal. With low grade products you are not getting a deal at all.

A good starter kit comes from Airbrush Bodyart. The kit contains everything you need to get you started creating airbrush art tattoos and then some. In their starter kit they include 2 single action ABA airbrushes, 2 hoses, 9 glass airbrush bottles, a 2 outlet air manifold, 7 60ml airbrush tattoo ink in red, blue, white, yellow violet, fuchsia and green and the kit includes a 120ml of black airbrush tattoo ink. The starter kit also gives you 50 Vynalaser stencils that can be reused over and over again. Airbrush Bodyart's starter kit runs around $293. Individually all the same products that you get in the kit would run you around $346.

If you want to step your airbrush kit up then Airbrush Body art offers a professional kit. This kit includes a 4 outlet air manifold, 4 single action ABA airbrushes, 12 glass airbrush bottles, 4 air hoses, 10 60ml of airbrush art tattoo

inks in white, blue, red, yellow, violet, fuchsia, green, fluorescent green, fluorescent yellow and fluorescent blue and 1 120ml of black airbrush tattoo ink. Also added with this airbrush art tattoo kit is 1 120gm holographic glitter pack and 100 Vynalaser stencils that are reusable. The kit runs around $544 whereas individually purchased these items would cost you around $639.

For those of you who have experience in airbrush art tattoos and want a kit that will allow you to open up your own business doing airbrush art tattoos professionally, Airbrush Bodyart has you covered. They offer the Airbrush Volume Parlor 2000 kit. This kit gives you everything that you need to open up shop and start creating great professional airbrush art tattoos.

The Airbrush Volume Parlor 2000 kit contains a 4 outlet air manifold, 4 duel action ABA siphon feed kit, 4 glass airbrush bottles, airbrush holder, 1 regulator filter moisture trap, 10 60ml airbrush art tattoo ink in white, blue, red, yellow, violet, fuchsia, green, fluorescent green, fluorescent yellow and fluorescent blue as well as 1 500ml of black airbrush tattoo ink. Also included in this kit is 1 120gm jar of holographic glitter, 300 Vynalaser stencils that are reusable and a CD-Rom that gives you Flash displays for your customers. This kit will run you around $994 whereas the items purchased individually would run you around $1,242.

As you can see using a kit to get you started learning about airbrush art tattoos or to get enough product to start your business is cheaper than purchasing individual items. Of course after you have started it won't cost as much to replace items as you need them individually. But to get them all at once separately can run a lot, so if you are just

starting out needing everything then the kits are you way to go.

Care Instructions For Airbrush Art Tattoos

When doing airbrush art tattoos there are some things that must been done to ensure that the airbrush tattoo ink sticks to the skin and does not fade quickly. When the prep work is done right and the customer understands the care instructions they can get many days of realistic looking artwork on their bodies. With the time and cost of creating great realistic airbrush art tattoos one does not want it to fade within a couple of days.

While an experienced airbrush artist may know this a beginner may not, so it is worth mentioning. When doing airbrush art on skin, make sure you are using airbrush paint that is designed for the skin. Usually this will be sold as airbrush body paint or airbrush temporary tattoo ink. These are the only types of airbrush paints that are safe to use on the human skin.

These paints will have a hard time staying on skin that is oily. A tattoo artist will rub alcohol on a person's skin to kill clean and kill germs prior to beginning to start a tattoo. In this case you are still going to use the alcohol but for airbrush tattoos it is to get rid of the oil on the skin and not to sanitize an area for a needle. Once you have removed the oil from the area the airbrush art tattoo will stick a lot better. This will give more life to the tattoo.

Now that you are ready to begin airbrushing the tattoo on, you need to take your time and be careful of what you are doing. There are no rooms for mistakes with airbrushing on a person's skin. So take your time to ensure you don't make a mistake on a person's body with the airbrush paint.

While experienced artists understand this, again a beginner may not. So it was worth mentioning as well.

After the airbrush art tattoo is completely dry then you need to apply talc powder. The talc powder will help to absorb additional oily ensuring more life for the tattoo. An airbrushed tattoo should last for 7 days. A person with oily skin will only get around a couple of days from their tattoo. Therefore you should tell your customers who have oily skin that they need to apply talc powder themselves several times a day to help get the most from their tattoo. A person with dry skin will get more than 7 days usually from the tattoo. It does not matter though if they have dry or oily skin you should apply talc powder as soon as the airbrush art tattoo dries.

Airbrush tattoos do cost money and customers are not going to spend that money if their tattoo does not last for at least close to what is expected. So make sure that you take all the prep and post steps to ensure that they do get a great realistic looking tattoo. Create a care sheet for your customers so that they will know how to take care of their new tattoo.

Learning More About Airbrush Art

Airbrush Art Expert-Pamela Shanteau

Pamela Shanteau is a renowned airbrush artists who's airbrush talent streams over multiple styles and surfaces. She is recognized among her peers and airbrush enthusiasts for your custom airbrush art. Her surfaces choices for her airbrush art include automotive and motorcycles and the body. It is her airbrush art on the motorcycles that has placed her in the ranks with other famous custom airbrush artists.

Her airbrush art has been featured in the 2006 Iwata, the RM 2006 and the 2007 Paint calendars. The 2006 and also the 2007 Signature Harley Davidson calendars have featured Shanteau's airbrush art. While these calendars show off a great deal of her talent they are by far not the only place where you can see this expert airbrush artist.

Magazines such as Hot Rod, Airbrush Action, AutoGraphics, Easy Rider, Mini-Truckin have featured Shanteau's airbrush art in their publications. These of course are just the tip of the iceberg when it comes to publications that have featured her work.

Shanteau does not just create brilliant airbrush art; she also teaches others how to create the same high quality airbrush art that she herself creates. In February of 2002 she released the book, The Ultimate Airbrush Handbook. In this book she teaches the basics of airbrush art, airbrush types and how to set up an airbrush shop. The book covers such styles of airbrushing such as fingernails, automotive, t-shirts and even leather. In July of 2007

Shanteau released another book to help other artists learn the art of airbrushing. Her book titled, Custom Automotive & Motorcycle Airbrushing teaches never before seen techniques.

These techniques are her own exclusive techniques she created and she is sharing them with you.

Shanteau offers visual DVD and vhs tapes to help other learn how to create airbrush art on automotives and motorcycles. These videos show you step by step exactly how to do certain techniques to create specific looks. Her series teaches about airbrushing flames, murals and masking techniques and motorcycle gas taking airbrushing. Her videos will give you a more visual learning aid than you would get from the detailed directions in her books, so if you learn better from watching then the videos are your best bet when learning from Shanteau.

Pamela Shanteau also teaches workshops around the United States that offer a hands on learning experience for airbrush artists. Her workshops allow for students to learn her techniques and gain more knowledge while under her supervision. She is there to show you how to do airbrush art, help you quickly spot your mistakes and learn how to advance in your techniques.

Shanteau is truly a gifted airbrush artists and the chance to learn from her will greatly benefit any artist from beginner to advanced. Her styles and techniques are unique to her and she is openly offering to show them to others who truly want to learn airbrush art. She has given artists three great mediums in which to learn from her distinctive personal style. It is this distinctive style that has her ranked high in the airbrush art industry.

Books for Beginners to Advanced

When looking to learn on your own about airbrush art, reading is one area where you can gain a wealth of information to help you learn more. There a lot of great books out there that will help you from the beginner level of experience all the way through to the expert level. Books designed to teach airbrush art can be used alone or along with magazines and videos. To get you started are the following books covering beginner and advance information on airbrushing.

If you are just now looking into learning airbrush art then Airbrush by Parramon's Team is your best bet to start with. The book explains all about airbrushes and the uses of airbrushes. Instructions are also included in the book on how to use each airbrush. So someone who has no real prior knowledge this book will help you understand the airbrushes that you will be using when creating airbrushed artwork.

Getting Started in Airbrush by David Miller is also a great beginner's book on airbrushing. The book will give step-by-step instructions on the basic level of airbrushing techniques and how to create different effects with your airbrush art. By reading this book you will learn about the equipment and other materials that you will be using. The effects that you will learn about include freehand, edge effects, highlights, lettering and several others.

How to Airbrush T-shirts and Other Clothing by Diana Martin is good for beginners or can be used by the more experience airbrush artist who wants to learn the techniques used for airbrushing textiles. This book

contains information on all the equipment, materials and techniques needed to create airbrush art on textiles. With 18 step-by-step guides you will be fast on your way to showing off your work on clothing.

Professional Airbrush Techniques by Vince Goodeve will teach you some pretty intricate designs. This book will help you learn how to prepare metal surfaces so that you can begin to learn or advance with airbrush art on motorcycles and cars. While the book will teach you some intricate designs do not worry though cause the book, also has some simple projects that you can start with when working with airbrushing motorcycles and cars.

If you are at an intermediate level with airbrush art then The Ultimate Airbrush Handbook by Pamela Shanteau is for you. This book will show you all about airbrushing everything from t-shirts to home interiors. Almost all surfaces for airbrush art are covered at the intermediate level in this book. Airbrushing nails to airbrushing cars is explained in great detail to help you advance further no matter what surface you like to put your airbrush art on.

Airbrush2: Concepts for the Advanced Artist by Radu Vero will help to teach the experienced artist more advanced techniques. By learning these advanced techniques the artist can start to create even more complex airbrush art. After all in the world of art there is always room to learn more and advance one's way of doing something to create a whole new aspect for the current art.

DVDS For Beginners

Some people are fully visual people. This means that they learn and comprehend better when they see how something is done versus reading about how to do it. While most magazines and books will offer some pictures this is not enough for a fully visual person. So when someone is fully visual and they want to learn something the best thing they can do is watch videos that show how to do something. There are some great videos on the market that will show a beginner how to do airbrush art. These videos are created by expert airbrush artists that will show you exactly what you need to know.

Air Brush Action offers up a good beginner's video called AirBrush Action Introduction to Airbrush. This video comes on DVD and will help you to learn about airbrush art. You will get 1 hour and 30 minutes of techniques and principles of airbrushing that will apply to all types of airbrush art. The video features Air Brush Action's Teacher of the Year for 1995, Debbie Eastlack.

Paasche a name brand in airbrushes and airbrush accessories offers up an exceptional video titled PAASCHE Airbrushing with the VL. This video is offered on DVD and runs about 30 minutes. This video deals with teaching the beginner all about double action airbrushes. In spite of the fact that the video is geared towards the Paasche VL airbrush, the information taught in this video will work for any double action airbrush on the market. Beginners can learn about internal and external mix, paint feed systems as well as airbrush paints. Learn troubleshooting and how to take care of your airbrush. This

is a very in depth 30 minute video that will teach a lot to a beginner when it comes to airbrush art.

One video that is great for beginners that are interested in airbrush art tattoos is the SHOW OFFS BODY ART How to Airbrush Tattoos. This video is on DVD and runs about 90 minutes. Through this video Donna Nowak will walk you through all aspects from equipment and materials to the application process. Learn some tricks on how to create great airbrush art tattoos. This video will walk you through it all step-by-step so that you really understand the process behind airbrush art tattoos.

If creating custom airbrushed t-shirts seems to be your interest but you have no experience in airbrush art then Kent Lind has the video for you.

Kent Lind will show you t-shirt airbrush art in his video Introduction To T-Shirt Airbrushing. This video is intended for beginners to learn first how to construct an airbrush and also for cleaning purposes how to take the airbrush apart. Cleaning the airbrush is covered in this video as well. For the actual creation of artwork you will learn about the dagger/flare stroke, styles and basics on lettering and color theory. Kent Lind will also show you how to promote your talent. Airbrush exercises in this video will include rendering blends, shadows and even hot spots.

Advanced DVDs

Once you have learned the basics with airbrush art, you can start to learn more advanced techniques. These advanced techniques will help you to render more imaginative art. Videos can help you learn this advanced airbrush art techniques. You can also get videos that will help you learn how to render a specific design that will fit with the airbrush art you are trying to create.

One such specific design video is Creating Killer Dragons, produced by AirBrush Action Magazine with master airbrush artist Crossed Eyed. Crossed Eyed will teach you how to create airbrushed dragons by showing you all the essential techniques involved in rendering all aspects of the dragon.

Killer Klown with Javier Soto will show you how to create airbrushed clowns. This video will go into how to create the popular psycho demented style of clowns. These style of clowns seem to very popular with custom paint jobs. so if you are wanting to get in on how to create these clowns, then this video is for you. Javier Soto will deal with the use of bright colors, textures, highlighting and the use of kandies in creating a brilliant looking psycho clown.

Kustom Pinstriping Techniques featuring airbrush artist Craig Fraser will show you all the aspects of pin striping. This video will show you everything you need to comprehend about pin striping so that you can reach professional level pin striping. With this video you can learn about the design and application process, the different types of airbrushes for pin stripping and which brush is right for which job. Learn about choosing paints

and other material that you will need. Practice exercises will have you practicing what you see on the video so that you can master your skills.

Biker Skull featuring renowned airbrush artist Robert Benedict will show you step-by-step how to create a professional looking skull in a leather cap. This video is a very advanced detail orientated video that is a one of a kind as the methods and such have never been put on tape before. With this video you will learn what you need to have an edge over a lot of other airbrush artists.

Caricatures are seen in a lot of art and airbrush art makes for creating some really interesting caricatures. Kent Lind will show you how to create cool caricatures in this approximately 70 minute video titled, How to Airbrush Caricatures. This video will go into all the details that you will need to know to create your own airbrush art caricatures. These designs are great on t-shirts, canvas and if you really want you can put then on your car.

After all, art is all about imagination and showing off your creative imagination. Advancing your techniques and learning new design methods can help you to advance your airbrush art. Once you have learned the advance techniques and design styles offered in these advanced articles, you can then customize what you learned to create airbrush art that is truly your own.

Airbrush Art Magazines

Almost all forms of art has a publications aimed at that particular art. Airbrush art is no different. There are a diversity of magazine publications to appeal to airbrush artists out there. Some magazines are in print and with the access of the internet there are airbrush art magazine online as well. Whether you are reading and learning more about airbrushing in a printed magazine or an online magazine you are sure to gain knowledge of the airbrush art industry. Airbrush art can be seen in magazines that are designed to teach techniques geared toward airbrushing in a more broad-spectrum. Airbrush art can also be seen in magazines geared toward airbrushing cars or bikes and such, making for much more precise content toward a more specific niche.

Airbrush Technique Magazine is a broad spectrum magazine that is geared to teach techniques of airbrush art no matter what you are airbrushing. The publication is subscription based and can be obtain with a one year or a two year subscription. This is a good one if you just want to gain more knowledge on airbrushing techniques whether you airbrush as a hobby or you do it professionally. The wide array of surfaces that Airbrush Technique Magazine covers includes but not limited to t-shirts, canvas, the body, autos, motorcycles and so much more.

Airbrush Artist Magazine is a broad spectrum online membership based magazine. The online magazine offers articles, tutorials and videos to help you learn more about airbrush art. The magazine offers unlimited access to all of this with your membership to their online magazine.

Airbrush Artists Magazine is updated once a month and aims to offer a minimum of two new lessons, tutorials and articles each month.

Art Scene International formerly known as Airbrush Art + Action magazine is a European based airbrush art magazine. The magazine is now being distributed in North America. While it has gained a large digital imaging interest the magazine is still a great asset to any airbrush artist. The magazine has full color images and is full of artist stories and how to articles that will help any airbrush artist.

Air Brush Action magazine is a publication on airbrush art that seems to have specific main niche for each publication. While each issue may include some other forms of airbrush art, the issue has a main theme throughout. The publication has buyer's guides, tips and tricks, artist bios and so much more that is sure to be appreciated by any airbrush artist. By offering a major theme each month there is more chance of appealing to a wide array of readers.

If you are into automotive airbrushing then by grabbing one of their automotive issues you are guaranteed to get an issue that really goes all out on automobile instead of just a few mentions in the magazine on that particular niche of airbrush art. So keep tabs each month on their publications to see if they are covering your style of airbrush art.

A Look At Workshops

Learning airbrush art from books and videos can only take you so far with your art. To take things to the next level and gain some insight straight from an expert, then enroll in an airbrush art workshop. Airbrush art workshops are offered around the world by many expert artists who will show you up close and personal how to create art like a pro. These workshops range from beginners to advanced classes. Each artist and each individual workshop will teach you something new and exciting about the world of airbrush art.

The Learning and Product Expo: Art is one such place to take part in workshops with airbrush experts and gain some hands on experience. While under the supervision of an expert you can quickly learn where you are making some mistakes with your work. Expert instructors include Peter West and Pamela Shanteau who hold classes at the Learning and Product Expo: Art for beginners through to advanced.

AirBrush Action offers their Airbrush Getaway Workshops that run from a one day class to four day classes and are located in Las Vegas, Nevada. The workshops offered cover airbrush t-shirt art, murals on steel introduction, achieving photorealism, pinup art, pin striping and much more on airbrush art. The pricing for AirBrush Action's workshops runs $150 for a one day class and $575 for the four day classes. This is a small price to pay to learn hands on with experts such as Cross-Eyed, Javier Soto, Jonathan Pantaleon and Craig Fraser.

In the UK airbrush art workshops are being offered by Organic Image with instructor Beej Curtis. Beej Curtis instructs on airbrush art in 1 and 2 day classes covering different aspects of airbrush art. Beej Curtis also offers private 1 on 1 lesson for anyone wanting to learn in a more private setting. The private lessons are 3 day classes that will take you from beginner to advanced airbrush art techniques. If you have experience then start where you know and go forward advancing through airbrush art techniques.

Workshops can cover a wide variety of different styles and techniques of airbrush art. Makeup artists that practice airbrush art for makeup sometimes will offer workshops in their salons to teach the art of airbrush makeup. So when interested in learning about how to apply airbrush make-up then look into the websites for artists that practice this form of airbrush art. Usually they will have a place on their website that talks about offered workshops. One such airbrush artist is Suzanne Patterson of Creative artistry. Suzanne Patterson has held several workshops teaching people hands on all about the art of applying airbrush makeup.

With airbrush art is does not matter what your skill level is because there is a workshop out there for you. So even if you have read almost nothing on airbrush art or tried anything with airbrushes then learn all about it in a beginner's airbrush workshop. Find the workshop that works for what you want and need to learn then get ready to learn hands on from the masters of airbrush art.

Why You Should Learn Micro Airbrush Art

Micro Airbrushing is a valuable skill for all airbrush artists. Being able to do micro airbrushing will allow for the artist to create a more realistic and more in depth detail on all small areas of their airbrush design. It is in these small areas that a lot of artists miss the chance to really define the details because they are unable to fully create the detailed area. Micro airbrushing is needed to really capture the details of these small areas. Micro airbrushing is also a valuable skill for an airbrush artist if they airbrush small model cars. By acquiring the skills needed to do micro airbrushing the artist can capture more detail in their airbrush art on the model car.

Imagine being able to create realistic eyes on a dragon you just airbrushed onto the hood of a small model car? When a person looks strongly at your artwork on the hood of the model car they can really see the capacity of the skills that you have as an airbrush artist. Or imagine that no matter what size your project is, even the fine details are brought out to the point that they demand to be noticed. All this can be done if an artist takes the time to learn micro airbrushing. There are a couple of ways that an artist can learn how to do micro airbrush art.

One way that an artist can learn how to do micro airbrush art is to obtain a video created just to teach micro airbrushing. AirBrush Action has a video titled Micro Airbrushing that features airbrush artist Robert Benedict. With this video you will be shown how to airbrush 23 skulls onto an area the size of a dime. This video will show you everything that you would every need to know about working with micro airbrushing. A couple of great features

of the video is that you will learn how to truly work with House of Kolors paints and how to work with low air pressures. Learn more about how to do freehand is also a great asset of this video. These are advanced techniques and will take you as an artist to the next level of airbrush art.

Another way an artist can learn micro airbrushing is to work directly with an expert. Take on a workshop that teaches micro airbrushing and you can learn with some hands on projects under the supervision of an expert. Working with an expert can also mean signing up for some private one on one lessons that will give you more direct attention from the instructor. This could give you a little bit more of an edge over taking a work shop where the instructor has many people to teach at one time.

Once you have mastered your skills in micro airbrush art you will be amazed at the amount of detail that you can place in any airbrushing project. This ability will help set you apart from the rest of the competition and allow you to reach the top of the airbrush art industry. Becoming a truly renowned artist in your trade is dependent upon just how much detail you can capture in your work compared to other artists.

www.ingramcontent.com/pod-product-compliance
Lightning Source LLC
Chambersburg PA
CBHW061519180526
45171CB00001B/253